A Memoir of

George Stubbs

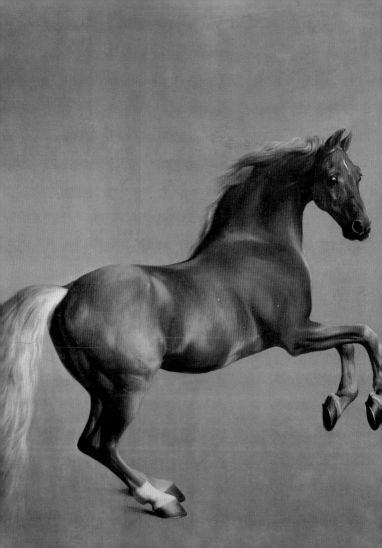

A MEMOIR OF

GEORGE STUBBS

BY

OZIAS HUMPHRY
AND
JOSEPH MAYER

with an introduction by
ANTHONY MOULD

PALLAS ATHENE

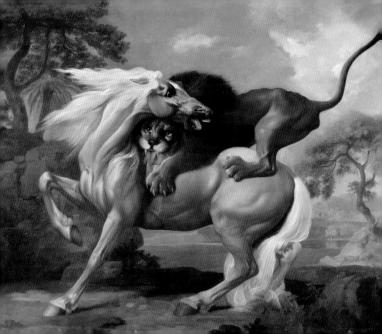

CONTENTS

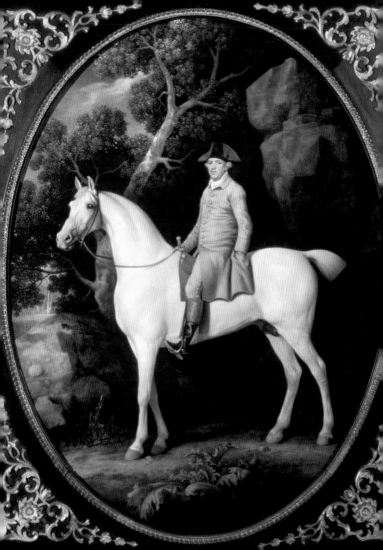

INTRODUCTION

ANTHONY MOULD

George Stubbs had no Boswell. Indeed it was not until 1876, sixty years after Stubbs' death, that any attempt to write his life was made. This was the essay published here, which was written by a fellow Liverpudlian, the art patron and enthusiast for his city, Joseph Mayer (1803-1886). Stubbs was by this time almost completely forgotten, so it is no surprise that Mayer's essay was self-consciously a manifesto, advertising to a fairly indifferent Victorian audience the genius of a painter for whom the collector had a strong personal predilection.

But Mayer's essay has a greater intrinsic interest than this suggests. It is in fact the closest we can get to a contemporary interview with Stubbs, for it is based on manuscript recollections left by Stubbs' contemporary, Ozias Humphry. Humphry, a minor painter, was certainly no Boswell, but he was a would-be Vasari. In 1797, when Stubbs was 73, Humphry seems to have had one or more conversations with him about the painter's life and career. Humphry

Opposite: Self-portrait on a white hunter, enamel on earthenware, 1782

never wrote up his notes properly, but they were transcribed and augmented by his relative, the manuscript collector William Upcott, who had himself been in touch with Stubbs' family and had probably writtten the brief obituary that appeared in the Gentleman's Magazine. All this rather scrappy but hugely informative material Mayer brought together into a more coherent whole, and he circulated the resulting essay privately in 1876, as part of a volume entitled Early Art in Liverpool, *and again in 1879, in* Memoirs of Thomas Dodd, William Upcott, and George Stubbs RA.

As Mayer hoped, it was the beginning of a slow revival of interest in Stubbs. In 1898 Walter Gilbey published (also privately) his Life of George Stubbs RA; *this went deeper but did not significantly alter Mayer's view of the artist. In the 1920's Walter Shaw-Sparrow enlarged on the biographical material in his* British Sporting Artists *(1923),* George Stubbs and Ben Marshall *(1929), and* A Book of Sporting Painters *(1931). But it was left to the poet Geoffrey Grigson to bring a more critical sophistication to bear in* Signature *(1938) and* The Harp of Aeolus *(1947). Grigson set the tone of subsequent analysis that went beyond that of just painting and pointed out that Stubbs' tastes were those of 'an experimenter and observer'. Stubbs exhibitions in Liverpool in 1951 and at London's Whitechapel Art Gallery in 1957 opened the door onto wider recognition and modern scholarship. Within fifty years,* Whistlejacket

had become one of the most popular – if not the most popular – paintings in the National Gallery.

Nevertheless, there is still much unknown about Stubbs. The energetic perceptions of Basil Taylor brought greater focus to the scientific and veterinary aspects of the œuvre, but Taylor's untimely death left much brilliant work unfinished. Stubbs himself remains largely silent but for the occasional letter or reported remark. There is no sitter's book extant, and the catalogue of the posthumous sale of his effects in 1807 is mute evidence of how much has been lost: still lives, portraits, religious paintings such as a Descent from the Cross *(Lot 70 on day 2), and many drawings in particular. Some of this material will no doubt emerge over time, and will enlarge our understanding of his working methods, but until it does the Humphry/Upcott manuscripts and the edition of them by Mayer remain, whatever their shortcomings, the most comprehensive primary source we have.*

George Stubbs was born in Dale Street in Liverpool (then 'a remote commercial town where little is heard of save Guinea-ships, slaves, blacks and merchandise', in the words of one contemporary) on August 25, 1724. His father was

Overleaf: A cheetah with a stag and two Indian servants 1764-5. This may record an experimental hunt instigated by the Duke of Cumberland

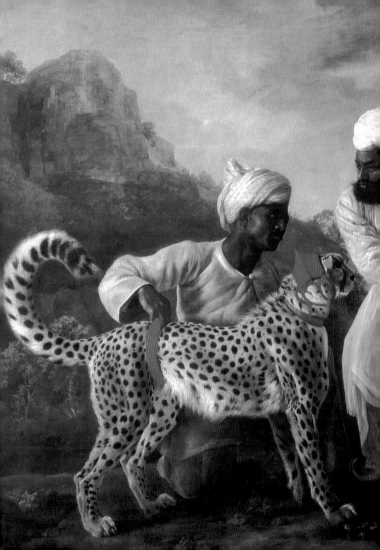

'Honest John' Stubbs, a prosperous currier, and Basil Taylor suggests that the young Stubbs' social background was not dissimilar to that of the young John Constable. Little is known of his early life save that at the age of eight he began to make drawings from bones borrowed from a Dr Holt in Liverpool. (None of these drawings survives.) Stubbs was of course intended for the leather trade, but when he was 15 his father acceded to his artistic ambitions, and apprenticed him at a shilling a day to the Warrington portrait painter Hamlet Winstanley, who was then engaged in copying the Earl of Derby's pictures at Knowsley. This arrangement lasted a few weeks only, and according to Humphry ended in acrimony. Stubbs determined that 'henceforward he would look to nature for himself and consult and study her only': the patterns of an independent mind were already crystallising. Until the age of almost 20 he continued to pursue his artistic and anatomical studies alone.

Between 1743 and 1744 he left Liverpool, first for Wigan (then the larger town), where he worked as a portrait painter, and then for Leeds, where his chief patron was a Mr Wilson, possibly the painter Benjamin, (himself much patronised at Wentworth Woodhouse) who found him employment again as a portrait painter amongst family and friends. There is tantalisingly little known about this period, and as yet no portraits have appeared.

From Leeds Stubbs moved to York in about 1745. Here

at the age of only 21 he was already making a serious study of human and animal anatomy and giving lectures to pupils at the infirmary whilst maintaining himself still by portrait painting. The lectures were apparently given privately, and Charles Atkinson, the town surgeon, procured for him his first body for dissection. Intriguingly in the first day of the 1807 studio sale appears 'Lot 40, Sketch for the lay figure of Alice Atkinson who died at York aged 110, being the study for the large picture which Mr Stubbs painted for Dr Drake of York'.

Portraits from this period are now starting to surface, but more generally known are the illustrations made for Dr John Burton, man-midwife, the original for Dr Slop in Lawrence Sterne's Tristram Shandy. It was Burton's aim to counter the popular view of midwifery as undignified and unintellectual, and in 1751 he published his Complete System of Midwifery, which details the many ways a birth can go wrong. The graphic engravings were unsigned, and it was Mayer who first proved that they were by Stubbs. The anonymity is a mystery but human dissection was clearly a pastime that carried a social stigma. A much later letter from William Frankland to Joseph Banks alludes to the 'vile renown' in which Stubbs was held in York. Nevertheless he seems to have remained there (apart from a short visit to Hull) until about 1754, all the while continuing with his portrait painting, to which Frankland also

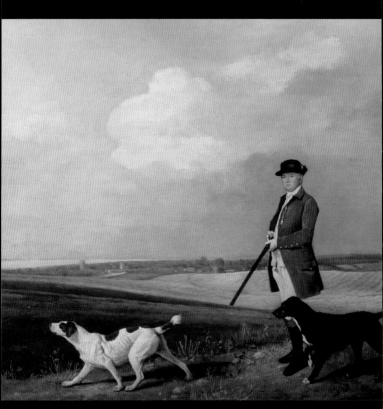

Sir John Nelthorpe shooting on Barton Field, near Horkstow, 1776.
His parents were loyal early patrons of Stubbs

refers. He also studied French and fencing, and had an enigmatic 'rencontre' with Mr Wynne, a dancing master, whose portrait he may well also have painted.

In 1754, perhaps supported by his portrait patrons the Nelthorpes and others in the Humberside region, Stubbs made the trip to Rome that was considered essential to an artist's education. With what may have been characteristic contrariness, Humphry and Mayer report that he went to convince himself that 'nature was and always is the superior to Art, whether Greek or Roman; and having received this conviction he immediately resolved upon returning home'. This he promptly did, and we do not know if he even bothered to see any other Italian cities. Already by Christmas 1755 we find him back in Liverpool painting a portrait of James Stanley, and organising family affairs after the death of his mother.

Not long after he had returned to nearby Hull to complete portrait commissions promised prior to his departure to Italy, mainly for friends of the ever-reliable Nelthorpes. By the beginning of 1758, however, he was engaged in a much greater, career changing enterprise; the putrid business of dissecting equine corpses for The Anatomy of the Horse. *Eighteen months he spent drawing in an isolated farmhouse at Horkstow, in a bleak Lincolnshire fen, entirely alone except for his companion Mary Spencer (a niece, according to Humphry, but more likely Stubbs' common-*

law wife). The finished drawings he took to London to be engraved, only to discover that none of the professionals would take it on. Characteristically he set about the task himself, and six years later published his work in twenty four plates (or 'Tables') and an extensive text. The Anatomy *superseded all previous works, and attracted international recognition that was to transform Stubbs' career. Mayer quotes an entire letter sent by a professor at Groningen in high praise. The book's success was due to Stubbs' ability to design images that combine tremendous formal balance with a minute attention to detail. Stripping through layers of 'muscles, fascias, ligaments, nerves, arteries, veins and glands' down to the bone, the plates are still considered definitive in their accuracy, and it is not without good reason that Basil Taylor counted Stubbs next to Leonardo as the greatest painter-scientist in the history of art.*

The move to London in 1759 marked a watershed in Stubbs' career. By 1763 he had firmly established himself at 24 Somerset Street, Portman Square where he lived until his death in 1806. Making every effort to broaden and diversify his market and making the acquaintance of Whig aristocracy under a young king, George III, Stubbs now found himself at the age of 36 enjoying the enthusiastic patronage of the rising generation of the old Whig landowning families, Richard Grosvenor, Viscounts Torrington and Bolingbroke, the Dukes of Grafton,

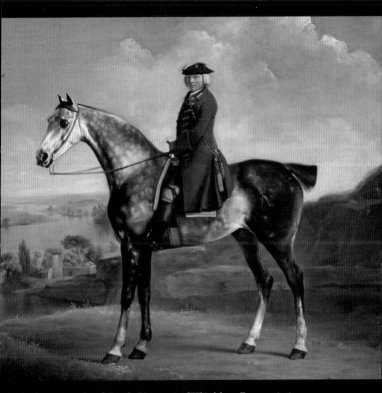

Joseph Smyth, Lieutenant of Whittlebury Forest, 1763-64
Smyth was for 52 years the agent for the Duke of Grafton,
hereditary warden of Whittlebury Forest in Northamptonshire,
who probably commissioned the painting

Richmond, and Portland, John Spencer of Althorp (soon to be the first Earl) and the Marquess of Rockingham. Many of these he may have met through Domenico Angelo, a famous riding and fencing master. His new patrons were wealthy and youthful, and entering the great era of horse racing and foxhunting, the breeding of horses and dogs for the chase and the field, and the scientific breeding of farm animals; this was a time of agricultural experiment and expansion, the study of natural history, and new attitudes to country life, all encouraging a new and unparalleled demand for animal paintings. Stubbs' response to this demand quietly transformed the character of English animal painting. As Mayer puts it, 'no temptation led him to invent a muscle nor did he put his creatures into an attitude. They are always as nature made, with their own shapes, gestures, and expressions – often ugly but always true.' But Stubbs did not confine this intellectual rigour and honesty to animals alone. The label 'animal painter' is manifestly too restrictive when we look at the range of his subjects and interests and consider his matchless understanding of the human figure and the expression of character in portraiture.

The course of Stubbs' subsequent career reveals the man as an uncompromising perfectionist, wrestling with the inevitable fluctuations of financial and artistic support. The range of subject matter continued to widen – portraits,

family groups, exotic animals (monkeys, a zebra, a moose, a cheetah all appear), as well as horses and riders of all sorts. His work was exhibited freely at the Incorporated Society of Painters of which he was Treasurer, and at the Royal Academy. His technical inquisitivess and virtuosity found a new outlet in his experiments with enamel painting. In 1769 Lord Melbourne bought the first work in enamel for 100 guineas: a Lion devouring a Horse,[1] although this contradicts Humphry's statement that the collaboration by Stubbs and Cosway in this medium began in the early years of the 1770's. By 1778 Wedgwood and Bentley were supplying large scale ceramic surfaces (2'6" high x 3'6'" wide) and these were an increasing feature of Stubbs' production, culminating perhaps in the Haymakers[2] and Reapers[3] in oval of 1794 and 1795.

By this time painting commissions were beginning to dry up, and patrons such as Wildman, Vane Tempest, Lord Gormanston, the Duke of Newcastle and the Duke of Marlborough became erratic in their support. A grandiose project, the Turf Review, to paint a series of portraits of famous racehorses from the Godolphin Arabian to horses of his own day, instigated by an anonymous patron who may

1. Tate Gallery 2 & 3. Yale Center for British Art. See page 62

Overleaf: Sir Peniston and Lady Lamb, later Lord and Lady Melbourne, with her father, Sir Ralph Milbanke, and brother, John Milbanke (1769)

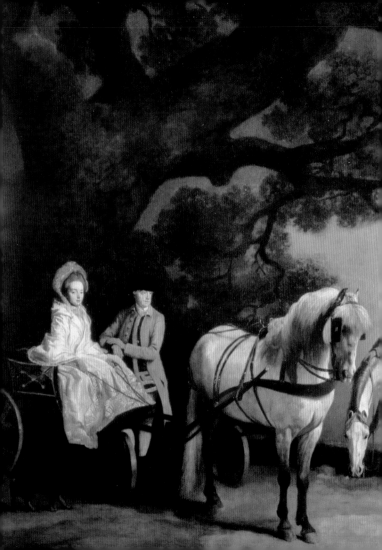

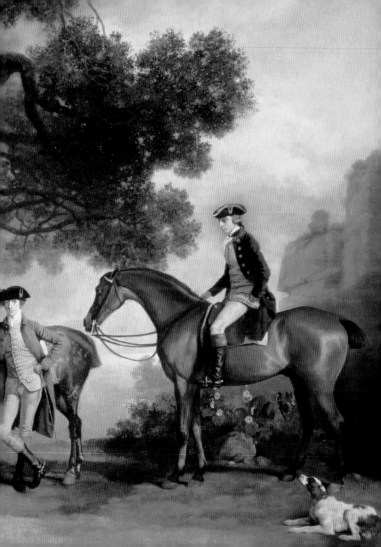

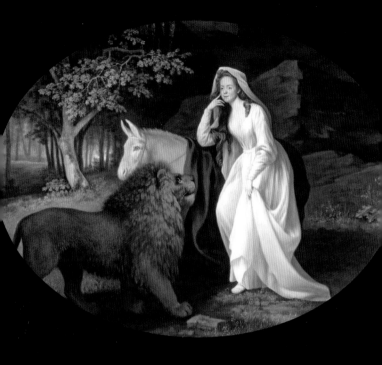

Isabella Saltonstall as Una, oil on enamel, 1782

*have been the Prince of Wales, sputtered out owing to a lack
of funds. The lack of pictures after 1794 confirms the tradi-
tion that he lived his last years in financial difficulty and
relied on the help of his friend Isabella Saltonstall who at
the end had a lien on most of his unsold work. (All the
enamels he is known to have made between 1791 and 1795
were still in his studio in 1806, as were the Turf Review pic-
tures.) But the lack of regular painting commissions liber-
ated his time for the ground breaking but alas incomplete*
Comparative Anatomy. *This 'Exposition of the Structure
of the Human Body, with that of a Tiger and common
Fowl', for which 30 plates were planned, would have been
a major scientific work.*

*Mentally and physically very strong to the end (he took
a nine-mile walk the day before he died), and uncompro-
mising in his views, Stubbs also seems to have suffered a
certain social loneliness. Even his self-portraits, with their
steady gaze, are notably taciturn. In them, and in his
work, one senses not just a fairness of mind but also com-
plexity and introspection. Yet these qualities never cloud the
innate grip on reality, and a constantly exercised discrimi-
nation. Joseph Mayer put it thus: 'He painted what he saw,
and never showed an immortal soul in a poodle's eye.' In his
silence Stubbs emerges as a master recorder of his time:
painter, natural historian, and dare one suggest it, at
moments, psychologist of a very high order.*

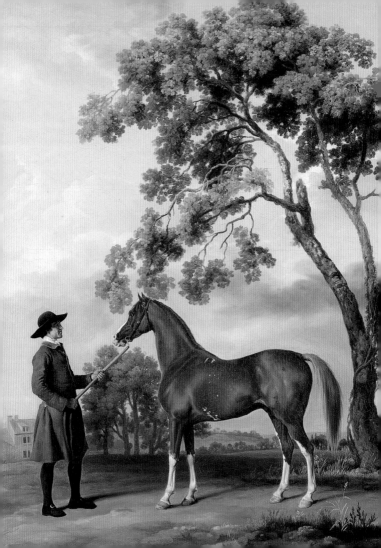

The name of this eminent artist is familiar to few people at the present day. In some great mansions the housekeeper will pronounce it, and a visitor who catches that unknown monosyllable in the midst of her drawling roll, may glance with admiration at the big picture overhead, but will probably again forget. And in the old county inns of Yorkshire, where men love the weight-carrying horse their fathers bred, you may find Stubbs' name on prints which the villagers still admire. By such works, indeed, he appears to be solely remembered amongst our critics. 'Stubbs?' they say— 'Oh, a man who painted racehorses!' Yet it may be observed that whilst the great Sir Joshua asked but seventy guineas for a portrait 'as far as the knees,' Stubbs' commissions ran to 100 guineas each.[1]

1. 'I am just returned from Blenheim; consequently did not see your letter till yesterday, as they neglected sending it to me. My prices for a head is thirty-five guineas; as far as the knees, seventy; and for a whole-length one hundred and fifty. It requires in general three sittings, about an hour and a half each time; but, if the sitter chooses it, the face could be begun and finished in one day; it is divided into separate times for the convenience and ease of the person who

Opposite: Lord Grosvenor's Arabian Stallion, with a groom (1776-70)

Nay, it seems probable that Sir Joshua paid for his picture of the *War Horse*[1] half as much again as he himself would have asked for a portrait of like size. The older a man grows, the less reason does he see to entertain youth's fond fancy that people come wiser as generations roll on. I, for my part, am quite convinced that in giving half-a-crown apiece for six Chelsea cups and saucers, my grandfather showed much more judgment than did a gentleman the other day who offered me fifteen guineas each. Holding a very strong belief that our forefathers, quite as much, to say the least, as we, were guided by common sense in what they did, I consider that the mere prices paid George Stubbs demand from us a little study of his merit. For he was no fashion. Of

sits; when the face is finished, the rest is done without troubling the sitter.

I have no picture of the kind you mention by me. When I paint any picture of invention it is always engaged before it is half-finished.

I beg leave to return my thanks for the favourable opinion you entertain of me, and am, with the greatest respect,

Your most obedient humble Servant,

JR

[Joshua Reynolds]

Addressed to Mr. Daulby,

To the care of Mr. Wm. Roscoe, Lord Street. (Mayer MSS.)

(1) Lost

the birth I shall presently show; not recommended by a patron, nor pushed by a clique, his very great success was due to nothing besides industry and talent. Observe that the same people who saw Reynolds' pictures, Gainsborough's, Wilson's, and Stubbs' — saw them side by side, and gave to the latter that substantial testimony I have mentioned to their approval of his display in the great competition.

He did not paint racehorses alone, nor was he only a painter. A man who qualified himself to give lectures on anatomy at York Hospital before he reached his twenty-second year, whose scientific knowledge, and skill in displaying it, called forth enthusiastic compliments from the savants of foreign lands; whose work Sir Edwin Landseer used for constant reference — such a man deserves to be remembered. In the library of Mr. Mayer, at Bebington, is a collection of notes written by Upcott, from the painter's lips. These have been gathered into connected form, and they are presented here with the hope that by their publication critics may be led to speak of George Stubbs in a tone less contemptuous than that we have lately heard.

Overleaf: The Prince of Wales's Phaeton, with the Coachman Samuel Thomas, a Tiger-Boy, and the Prince's spitz dog, Fino, 1793

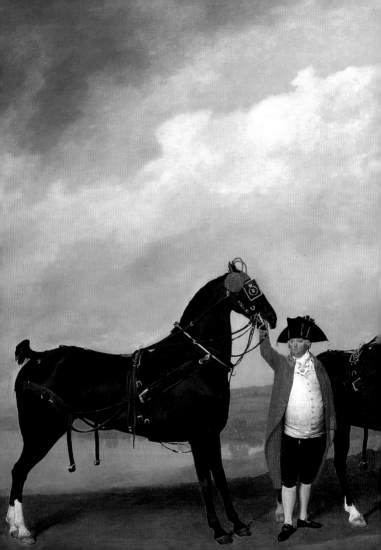

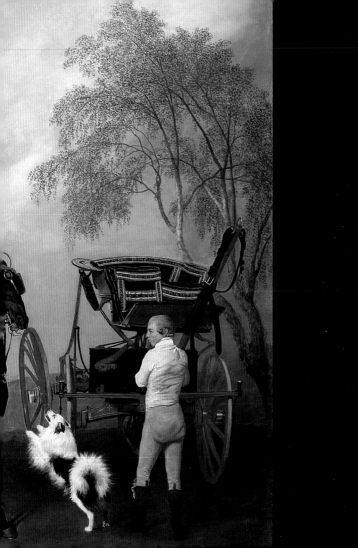

In *A Century of Painters*, Mr. Redgrave makes several mis-statements about Stubbs. We shall presently see that his father was not a surgeon, and that his predilection towards anatomy was caused by no such accident. Mr. Redgrave does not acknowledge Stubbs as an Academician, but the official list of the year 1805 contains his name. He never admitted himself to be an A. R. A. only, but claimed to be an Academician elect. As such he signed himself R.A. For the rest, Mr. Redgrave confesses that 'little is known of Stubbs' early life, or even whether his original bent was to the arts' — a blank which will be filled by this memoir.

George Stubbs was born at Liverpool, August 24, 1724. His father, we learn, was a 'considerable currier and leather-dresser'. A little tale which the son has preserved for us gives a pleasant picture of the elder Stubbs. It is not worth telling in detail, a century and a half after date, but we can see how it dwelt in the painter's memory. Young George goes for a Sunday walk, meets a party of his father's men, and gives an unlimited order for their entertainment at the Half-Way House, by Liverpool. The father hears of this generosity, and hastens to the inn, not to make a scene, but to satisfy himself that the score

is honourably settled. On finding that George's own resources have sufficed, he 'never from that moment mentioned a word of it.'

The bent of a painter's genius shows itself at an early age, but seldom, probably, in a form as practical as that of Stubbs. When scarcely eight years old, his father then living in Ormond Street, Liverpool, little George began to study anatomy. Dr. Holt, a neighbour, lent him bones and prepared subjects, from which he took drawings. His father does not appear to have held the prejudice so common at that time against painting as a profession, but he naturally desired that his only son should succeed to a business by which a comfortable income was secure. Accordingly, George stayed at home, and applied himself to leather-dressing. It seems likely, however, that he showed no taste for this employment, and his father gave way when the boy reached his fifteenth year. The elder Stubbs at that time fell into ill health. Seriously occupied with his son's future, he reflected that to succeed in painting a man has need of careful education. He therefore called the boy, and recommended him to seek a master competent to set him in the path of Fame and also of Fortune — the latter point seems, very naturally, to have been

foremost in the mind of 'honest John Stubbs,' as the neighbours called him. Thereafter he died, leaving his widow in comfortable circumstances.

There was at this time in Liverpool an artist of repute, Mr. Hamlet Winstanley, who occupied himself with copying the pictures in Knowsley Hall, the Earl of Derby's seat. Of the most notable among these he executed etchings, which are now in the possession of the Walpole family, descendants of the Earl of Suffolk. To this gentleman George Stubbs recommended himself by a successful copy of one of his own pictures taken from the Knowsley Gallery. Mr. Winstanley engaged the youth, who was not yet sixteen years old, to aid in the work at Knowsley, offering him the choice of pictures to be executed. In return, he undertook to give instruction, and to allow his pupil one shilling a day for pocket money. And thus matters were settled.

The engagement, however, did not last long. For his first essay George Stubbs cast his eye upon the celebrated *Cupid* by Van Dyck. In this admirable picture, the son of Venus is represented of an age more advanced than usual. Around him lie various symbols, emblematic of War, Painting, Architecture,

Music, &c., drawn by Snyders, with his utmost skill.
It is evident that George Stubbs must have worked
very hard, to think of venturing upon a copy of this
masterpiece. But Mr. Winstanley objected, remark-
ing that he wished himself to undertake that picture.
We are told, quaintly, that Stubbs 'paused and con-
sidered this refusal with surprise and some concern.'
He then desired to copy the *Ruins of Rome*, by Paolo
Veronese, another chef-d'œuvre of the Knowsley
collection. But it appeared that the master wished
this also for himself, whereupon, without either
pause or consideration, Stubbs recommended him
to 'copy them all, if he would, for, since neither his
word nor his engagement could be depended on, he
would have nothing further to do with him.
Henceforward he would look into Nature for him-
self, and consult and study her only.'

Observing this droll little quarrel with unpre-
judiced eyes, we cannot share the evident indigna-
tion of the painter at his master's conduct.
Winstanley would not suppose in making his
engagement, that this boy of sixteen could choose to
try his 'prentice hand on the most difficult pictures
of the gallery. With all our respect for Stubbs'
genius, we cannot think that it was equal to such

efforts at that time, and one rather admires the master's consideration in basing his refusal on the plea given, than the pupil's rash self-confidence.

But Stubbs persevered in the resolution so hotly expressed. He never copied any single picture throughout his long life, neither in Italy nor elsewhere. From this period, Nature was his only study, and experience his master.

Till nearly twenty years old he remained at Liverpool, in his mother's house. At that age he removed to Wigan, where he lodged with a Captain Blackbourne. This gentleman took the young painter in particular affection, perceiving in him a strong likeness to a son lately lost. After seven or eight months at Wigan, of which we have no further account, Stubbs removed again to Leeds, and set himself to portrait painting. His chief patron here was a Mr. Wilson, who found him employment amongst his family and friends. From Leeds Stubbs went to York for the purpose of executing some commissions, and here he began a regular study of anatomy — dissecting human and animal subjects.

Opposite: Green Monkey, 1774

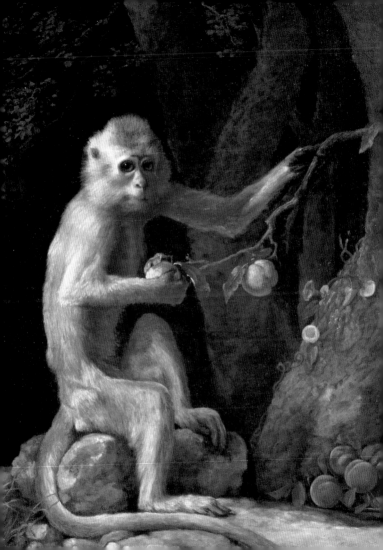

Mr. Charles Atkinson, a surgeon of the town, procured him his first body for dissection, and such progress did the artist make that he was employed before long in giving anatomical lectures privately to the pupils of the hospital. But this study did not engage all his time. We hear that he practised French and fencing, whilst maintaining himself by his profession. At the same time he had 'the rencontre' of which no particulars are given, with Mr. Wynne, the dancing-master, whose portrait is found in his list of works.' By the allusions to it, the 'rencontre' seems to have been an interesting affair. Some reader of this memoir may be able to give us the details omitted.

At York Stubbs made his first essay in engraving. Dr. Burton, physician and man-midwife of that town, applied to him to draw the illustrations of a work on midwifery. For this commission Stubbs had to make special studies. Fourteen or sixteen miles from York a 'subject' was found singularly fitted for dissection. The woman had died in childbed, and Stubbs' 'pupils' — by whom is meant apparently the pupils of the hospital — broke up her grave at night,

1. Untraced

and hid the body in a garret, where all dissections necessary were made. The designs complete, Dr. Burton was so well satisfied that he desired the artist to engrave them. Stubbs objected his entire ignorance of that art, but the doctor urged him to try, expressing confidence that whatever he attempted, his talent and perseverance would carry through. Stubbs consented at length, with great diffidence. At this time, he tells us, he had never seen any person engrave. In Leeds, however, he had known a house-painter, who sometimes practised that mystery, and to him Stubbs went to learn its rudiments. This very rough instructor taught him to cover a halfpenny with etching varnish and to smoke it; afterwards, with a common sewing needle stuck in a skewer, to etch after a fashion. Nothing beyond this could the house-painter impart, and Stubbs had no further tuition. Carrying the experiment into practise on his own account, he found the varnish so hard, that when he crossed his lines the wax flew off. A first attempt thus failing, he covered the plate with wax a second time, after warming, and held it to the fire till the wax ran off, leaving a smooth surface. After smoking this at a candle, he etched his figures on it. Working under such disadvantages, it is not surprising that the plates, when complete, failed to satisfy

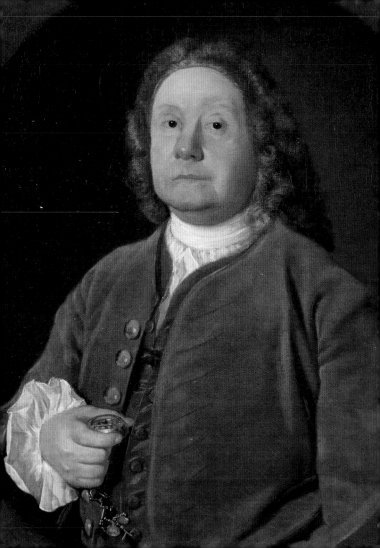

himself. Many of them were too small to be finished without the graver, an instrument quite new to his experience. He borrowed some from a clockmaker. Dr. Burton, however, was very well pleased, for, with all their imperfections, the plates are quite exact anatomically, and illustrate well the points in question. The work appeared in 1751, and several copies survive.[1]

Two or three years longer Stubbs remained at York. From thence, removing to Hull, he painted portraits and dissected assiduously. After a visit to Liverpool our artist embarked for Italy in the year 1754 apparently. A voyage of two months carried him to Leghorn, whence he proceeded to Rome. There, as we learn, he found Sir William Chambers, Jenkins, Brettingham, Wilson, Hamilton, Verpoil, and others, some of whom we recognise, and some whose fame has so long departed that we are surprised to find them named in such company.

It does not appear that whilst he stayed in Rome Stubbs ever copied a picture, designed one composition of the grand style, made a single drawing or a

1. Dr. John Burton, *An Essay towards a Complete New System of Midwifery*
Opposite: Portrait of George Fothergill of York, 1746

model from the antique. He desires it to be noticed that his motive for the voyage was to convince himself that Nature is superior to all art, whether Greek or Roman, ancient or contemporary. None but an ingenious mind could have felt doubt upon the question, and it tells for Stubbs' honest devotion that he should have undertaken such a voyage to satisfy himself. We are not told how long was the experience which brought him to a decision, but only that, 'being convinced, he immediately resolved to leave Rome.' One incident of his stay is mentioned: we learn that, 'whenever he accompanied the students in Rome to view the palaces of the Vatican, Borghese, Colonna, &c., and to consider the pictures there, he differed always in opinion from his companions, and when it was put to the vote, found himself alone on one side, and his friends on the other.' But he was not a man to be alarmed by isolation, or to be silenced by a majority.

Stubbs landed in London on his return from Italy, but he remained there only a week on this occasion, which seems to have been his first visit to the capital. From thence he betook himself to his mother's house, where pictures in abundance were proposed to him. Whilst executing these, he pursued his

studies in anatomy. Eighteen months after the Italian voyage Stubbs lost his mother, the settlement of whose affairs occupied him in Liverpool for many months. His first success of which we have record was gained at this time. The portrait of a grey mare[1] belonging to himself attracted much notice, and a picture dealer from London, Mr. Parsons, recommended the artist to move thither and win a fortune.

The dates contributed by Stubbs are very far between, nor can they be easily reconciled. Working upon such few hints as are given, it would seem that he left home in 1743, visiting Wigan and Leeds. In each of these towns he stayed some months, going on to York in 1744. His first attempt at engraving must date in 1747. Quitting York in 1752, he resided several months at Hull, then returned to Liverpool, and it appears that he sailed for Italy in the beginning of 1754. Stubbs finally deserted Liverpool in the year 1756, then being thirty-two years of age. His first resting-place appears to have been in Lincolnshire, where Lady Nelthorpe had long since given him commissions for a series of portraits.[2] Two years afterwards we find him at a farmhouse near

1. Untraced 2. Several of these survive in private collections.

Horkstow in that county, energetically preparing for his great work on the *Anatomy of the Horse*.[1] The house appears to have been lonely, for we are told that he engaged it to avoid inconveniencing neighbours by his dissections. Here Stubbs worked for eighteen months with one companion only, his niece,* Miss Spencer. This lady was the posthumous child of Captain Spencer, of the Guinea trade, who was killed by his favourite slave in a mutiny. She was born near the painter's house in Liverpool, and from the first had shown great interest in his studies.

The work thus laboriously carried through had long been present in Stubbs' mind. Upon it will rest his highest fame. The late Sir Edwin Landseer had the original drawings,[2] which he valued highly and consulted for his pictures. Nor did the work pass without appreciation in its own day. The following letter, which we reproduce in all its quaintness of expression, shows how foreigners regarded this excellent production:

* We have, however, no allusion to any brothers or sisters of Stubbs. In the original notes Miss Spencer is described as 'aunt', but this word is crossed out, and 'niece' substituted.

1. Published 1766. 2. Now in the Royal Academy, London

SIR, — If ever I was surprised to see a perform-
ance, I was it surely, when I saw yours on the
Anatomy of the Horse! The myology-neurology, and
angiology of men, have not been carried to such
perfection in two ages, as these horses by you.
How is it possible that a single man can execute
such a plan with so much accuracy and industry?
You have certainly had before you the scheme of
the great Albinus, but even his plates have not
that delicacy and fullness, nor the expression of
yours. Give me leave to ask you, was you the
engraver? for you do not mention the engraver's
name. I had once the plan to offer to the public,
a subscription for the like; but I am sure I could
not have obtained the elegancy and exactness of
yours. I dissected many horses; but I especially
examined the head, and all the different sections
of the inside, the bowels, and so on. I made fig-
ures as large as life. I dare venture to say they are
beautiful, mostly done by different means upon
the life itself. My intention was to reduce them to
one-eighth, and to have them engraved; but after
having seen and admired yours, I dropped all
hopes of succeeding. This favour I hope you'll
grant me, to inform me whether you still go on
to finish this beautiful undertaking, and whether

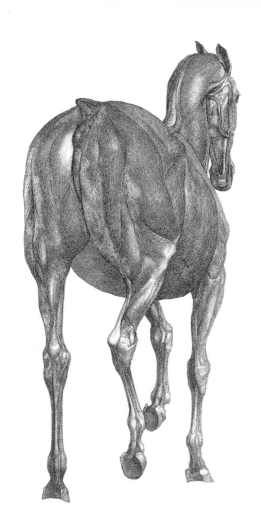

or not we may flatter ourselves to see the internal parts of this useful creature, and something about the disorders and internal diseases of the horse.

You will be curious to be acquainted with a Dutchman who admires with so much ecstacy your Tables. I am public professor of Medicine, Anat., and Surgery at Groningen; and I have published some figures of the human arm, pelvis, &c. I am actually publishing the Brain and the Organs of Hearing, Smelling, &c., in different animals. I dissect, but I do not love horses, though I keep them for proper use and for my family. I am sure my acquaintance can be of little use to you, but yours to me of great consequence. I desire to have two copies of your performance, one for me, and one for a gentleman who admires as well as I your book. I do not know whether your bookseller has any correspondence with us; if so, he may send them to any in Holland, and they will be sent to me, and which was perhaps more easy. Direct them to Mr. Fagel, junr., Greffier de leurs H(autes) Puissances les Etats généraux, à la Haye; and our ambassador will send them to the Hague. I'll get you

Opposite: Table XII from The Anatomy of the Horse

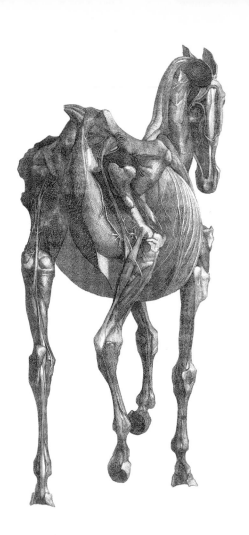

payed by my banker in London, Mr. Andrew Grote & Co.

Nothing shall be easier than to establish a correspondence with little or no expenses on both sides between us.

I am, with the greatest veneration, Sir,

Your most obedient and most humble servant,

PETRUS CAMPER F. R. S.,

Member of the R. Acad. of Surgery of Paris, of Edinburgh, and of the Societies of Harlem, and Rotterdam

At Groningen, 28th July, 1771.

This eminent anatomist writes in another letter:

The Duke of Wolfenbottle, the Baron du Sour, and I are the only owners of your elegant performance in these provinces, though it is much wondered at by others. I am amazed to meet in the same person so great an anatomist, so accurate a painter, and so excellent an engraver. It is a pity you do not like to pursue the viscera of this useful animal…

27th July, 1772

Opposite:: Table XIII from The Anatomy of the Horse

The 'M. Rev.' of 1767 ('Medical Review') is quoted to the following effect:

Anatomy of the Horse. — This work not only reflects great honour on the author, but on the country in which it was produced. France may reap great credit from the veterinarian school lately established in that country; but what praise is not due to a private person, who, at his own expense, and with the incredible labour and application of years, began, continued, and completed the admirable work before us! But it is impossible to give our readers an adequate idea of Mr. Stubbs' performance without placing the book itself before their eyes. All we can therefore add concerning it is, that the author himself dissected a great number of horses, for the sake of attaining that certainty and accuracy for which his engravings will ever (if we are not greatly mistaken) be highly valued by the curious in comparative anatomy. His original drawings were all his own, and the plates were likewise engraved by his own hand. In short, we are at a loss whether most to admire the artist as a dissector or as a painter of animals. Of his excellence in the last-mentioned capacity, few of our readers who have

any pretensions to connoisseurship can be supposed ignorant; especially as some of his admirable pieces have appeared at the public exhibitions. His pictures of the *Lion and Horse*, and *Lion and Stag*, in particular, were deservedly applauded by the best judges; nor were his *Brood Mares* less excellent, though in a very different style of painting; yet we think we have seen some of his animal portraits, both of wild and tame subjects, that are, if possible, superior to those above mentioned.

These extracts show that our artist had not long to wait for appreciation of his efforts. The above criticism is dated but twelve months after the appearance of the plates. We have some interesting details of the manner in which they were designed in the farmhouse by Horkstow. Stubbs tells that he fixed a bar of iron in the ceiling of his room. It was suspended by a 'teagle,' and hooks of various size and length were fixed to it; under this bar swung a plank, about eighteen inches wide, on which to rest the horse's feet. His body was suspended on the bar by the hooks above mentioned, which Stubbs fixed

Overleaf: Mares and Foals, 1762

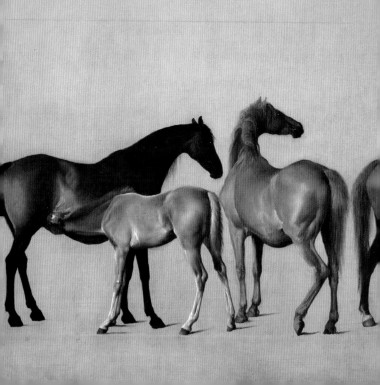

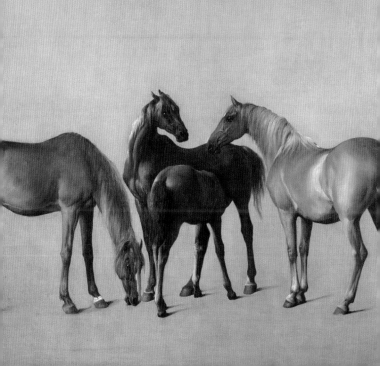

in the ribs and under the back bone, upon the further side of the animal. The horse was thus set in the attitude which these plates represent, and so remained for six or seven weeks, until no longer endurable. Like some other dissectors, Stubbs appears to have been indifferent to the odour of putridity, and even unconscious of it, as is shown by several anecdotes, ranging from childhood to old age.

The first subject dissected was bled to death by the jugular vein, after which the arteries and blood-vessels were injected. The artist began by dissecting and drawing the muscles of the abdomen, proceeding through fine layers of muscle till he came to the peritoneum and the pleura, through which appeared the lungs and the intestines. Afterwards the bowels were taken out and cast away. Then he proceeded to dissect the head, by first stripping off the skin, and, after having cleaned and prepared the muscles, &c., for drawing, he made careful designs of them, and wrote the explanations, which usually employed him a whole day. He then took off another lay of muscles, which he prepared, designed, and described in the same manner as is represented in the work; and so he proceeded till

he came to the skeleton. It must be noted that, by means of the injection, the muscles, the blood vessels, and the nerves retained their form to the last without undergoing any change. In this manner he advanced his work by stripping off the skin, and cleaning and preparing as much of the subject as he concluded would employ him a whole day to prepare, design, and describe, till the whole subject was completed.

The plates which form the publication consist of eighteen Tables, viz., six of the side view, whole length, from the tail to the nose of the Horse; one of the Bones, and two different lays of the Muscles; six of the Breast or Front view, and six of the Posterior view. These two latter plates differ from the rest in this respect: the posture of the first is still and motionless, whereas the two latter represent the Horse in the act of Trotting.

It would seem that Stubbs had not, at first, any notion of carrying out this great labour at his own expense and single handed. The idea of it had been broached amongst the anatomical students at York, and we perceive that the artist expected aid from some of them. But they all failed in their engagements, whatever they were, and Stubbs then resolved to bring this enterprise through without

help from anyone. Eighteen months of industry unremitted sufficed, and he took his drawings complete to London, where he hoped to find an engraver for them.

The date of his arrival is vaguely set at 1758 or 1759. The latter year seems most likely.

But the celebrated engravers of the day declined this commission, not, apparently, without scorn. Many of the drawings represented entire figures, but others there were showing parts only, a nose, an ear, a leg, and for such work Mr. Grignion, Mr. Pond, and their fellows, had neither habit nor liking. This unanimous refusal obliged the artist to do his own engraving once more, and he set about the task with characteristic resolution. What great success he had is well known, but the publication was necessarily retarded. For Stubbs never broke into the time devoted to his regular occupation of painting, and his etchings were made early in the morning or after hours. Often he worked late into the night. In about six years, or seven, they were complete, and the *Anatomy of the Horse* appeared in 1766. It was published by subscription, for Stubbs desired to make himself known, and, as he tells us, this seemed the

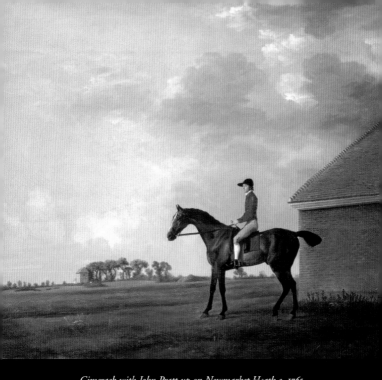

Gimcrack with John Pratt up on Newmarket Heath c. 1765

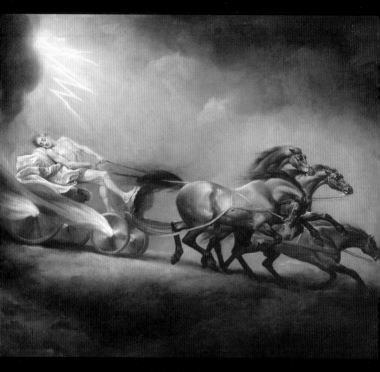

Fall of Phaeton, 1762

best means of achieving his purpose. 'More than any other thing, the book tended to throw him into horse painting, and to this he ascribes entirely his being a horse painter.'

Sir Joshua Reynolds gave one of his earliest commissions in this line, but he subsequently exchanged the picture for that representing the *Fall of Phaeton*,[1] in which the horses are roan.

The first commission of importance Stubbs received came from the Duke of Richmond, and it obliged him to take up his residence awhile at Goodwood, where he worked hard at his plates. In nine months there were several pictures painted, among them a hunting piece,[2] 9 feet by 6 feet, with many portraits. Of these was one of the Earl of Albermarle, painted whilst he sat at breakfast, the day before embarking on 'the ever-memorable and successful expedition to the Havannah, when it was taken.'

1. Saltram House, Devon 2. Goodwood House, Sussex

Overleaf: The Duchess of Richmond and Lady Louisa Lennox watching the Duke of Richmond's racehorses at exercise, 1759-60

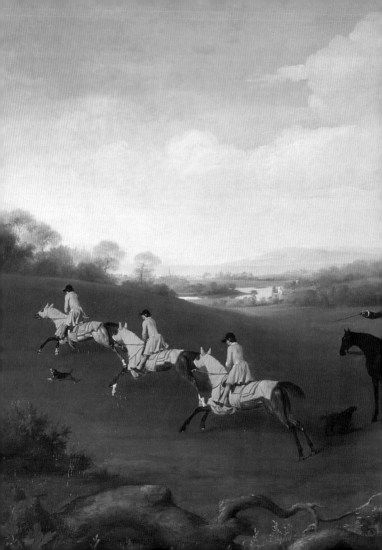

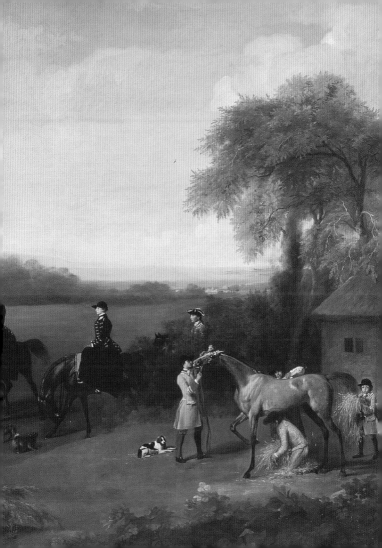

In 1763 Stubbs removed to No. 24, Somerset Street, Portman Square, where he resided till his death. For eight years past he had been treasurer of the first Incorporated Society of Painters, which held its exhibition in the Great Room, Spring Gardens, now pulled down. Upon the discontents which Mr. Paine had occasioned, Stubbs was chosen president for one year. But he felt the interruption caused by the duties of this office, and the experience, perhaps, was not without its effect upon his conduct in the subsequent dispute with the Academy.

In 1771, at the suggestion of Mr. Cosway, Stubbs began a series of elaborate experiments in enamel painting. He interrupted none of his regular employments for this new study, but we must notice that 'leisure days' are now mentioned instead of hours, and the compiler of these notes expresses a suspicion that Stubbs' general business in oil painting began to fail him at this moment for a time.

The artist was moderate in his hopes at first. He agreed to paint for Cosway on two conditions; one that tablets should be provided for him of the size of a quarter-sheet of post paper; the other, that his experiments in colour should be successful.

Accordingly, he began a course of chemistry, and pursued it for two years at great expense and endless labour, making careful memoranda of all his attempts. The colours he wanted were found at length, nineteen different tints. The record of these experiments is not given in any detail. We learn only that 100 lbs. weight of ordinary colour produced 81 lbs. some ounces of the improved material.

But this, which had been thought the greatest difficulty, did not prove to cause so much delay as the making of the plates. Not for three years after the colour was ready could the tablets which had been promised be procured in proper state. Meanwhile Stubbs painted on the largest copper-plates to be found. Enamel plates on copper of twelve inches square, and of eighteen inches by fifteen, could be obtained, and these he used. A larger size could not be made suitable for his purpose; sheet-copper must necessarily be thin, and therfore unequal to the weight of larger plates. Such sizes were by no means fitted to the ideas and ambition of our painter. He applied, therefore, to the pottery manufacturers, and, after some disappointment, Messrs. Wedgwood and Bentley undertook the commission. In 1778 they produced plates of thin earthenware 3 ft. 6 in. wide,

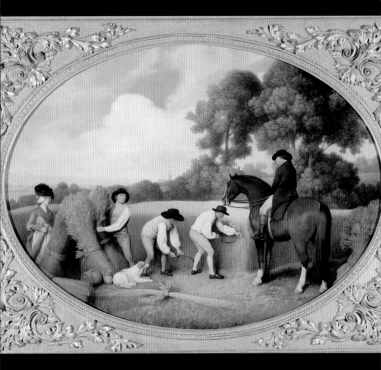

Reapers (oil on earthenware), 1795

by 2 ft. 6 in. high. Nothing to approach these dimensions had hitherto been used by enamel painters. Thereafter, Stubbs worked in oil colours or enamel, according to the fancy of his patron. The first picture he sold in enamel represented a lion devouring a horse. It was an octagon, on copper, and Lord Melbourne paid one hundred guineas for it.[1]

No single date is affixed to the stories and anecdotes communicated by the painter to Mr. Upcott. A number of them are grouped together without connection at this point in the life-story, but they seem to have their place here by accident, as it were. None of those given appear to have influenced his career appreciably, and their introduction will come with more propriety at the end of this brief notice. Suffice it, therefore, to say at present that Lord Torrington gave Stubbs much employment, as did the Marquis of Rockingham.

In the year 1780 he was elected an Associate of the Royal Academy, and in the next year a full Academician. But the formalities attending this appointment were never completed, though Stubbs

1. Tate Gallery. For Lord Melbourne, see p. 20

always claimed the dignity. The story of his celebrat-ed quarrel is probably told by his friend in the painter's own words; at least we may rely on it that he gives the full sense of them. Mr. Upcott writes as follows:—

The elections of Royal Academicians always take place on the 10th of February, and it is necessary, after the choice made, for the successful candidate to send a picture for his Majesty's approbation, previously to the diploma being signed. This com-pletes the honour of the election, and qualifies the new member for all duties required by the institu-tion. Whilst Stubbs was considering what picture he should present, whether in oil-colours or in enamel, the season of the annual exhibition arrived, to which many of his works were sent in both styles of painting. He had annexed a suitable explanation of the subjects, in the manner usual; but his mortification was great to find almost every picture so unfortunately hung, particularly those in enamel, that it seemed like an intention-al affront. Most of the quotations sent in were omitted. This treatment was much resented by Mr. Stubbs, and by those patrons for whom the pictures had been painted. He felt it with par-ticular sensibility, and to the time of his death

considered it cruel and unjust, as it tended more than any other circumstance could have done to discredit his enamel pictures, and to defeat the purpose of so much labour and study, not to mention his loss of time and great expense. This unkind conduct in the members of the Academy, added to the original reluctance with which he suffered his name to be entered among the candidates, determined him with an unconquerable resolution not to send a picture to be deposited in the schools, and more especially not to comply with a law made the following year, obliging every candidate elected to present the Academy with an example of his skill to be their property for ever. Mr. Stubbs always averred that he considered this law unjust, and thought he had reason to suppose it levelled particularly against himself. He regarded it, moreover, as an ex post facto law, calculated to punish an offence committed before the making of the law. Mr. Stubbs, on this account, would never allow that he was less than an Academician elect, waiting only the royal signature: and he was satisfied always to continue in that state.[1]

1 In 1805, however, the Academy gave up the long dispute. Their list of R.A.'s for that year contains the name of George Stubbs. He had always been described up to that date as A.R.A.

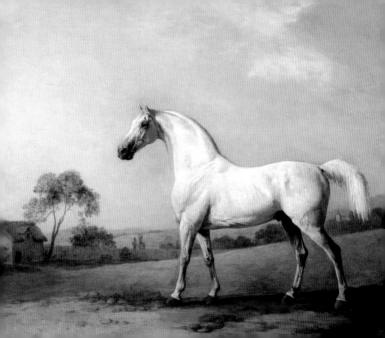

In fairness we must add the justification offered by the Hanging Committee for their treatment of Stubbs' pictures. They urged that the enamel colours were so bright, and their general effect so conspicuous, that no choice was left them, in justice to other exhibitors; and the paintings were accordingly placed on the top line.

In 1790 Stubbs undertook a commission from which he expected both fame and fortune. It was proposed to him to paint a series of pictures, portraits of celebrated racers, from the Godolphin Arabian to the most famous horses of his own day. The pictures were to be exhibited first, then engraved, and finally published in numbers, with a letterpress which should contain, beside a history of the Turf, the races and matches of each horse depicted, a description of it, and anecdotes. The sum offered for this commission was £9,000, deposited in a bank, whence the artist could draw it as his work progressed. It appears that Stubbs completed a great part of his engagement, but the outbreak of war ruined the enterprise. Sixteen pictures were painted, exhibited, and engraved; fourteen, if not all, in duplicate, large ones for framing, and small to accompany the letterpress. Thirteen of the

latter were engraved. After Stubbs' death, his executrix, Miss Spencer, before mentioned, kept possession of them. They were disposed of at the sale of his pictures.

Towards the end of his active life, Stubbs returned to those anatomical studies, by success in which he had gained his fame. He believed that he could show by plates a close analogy betwixt the human frame and that of various animals, even of birds and vegetables. To men of our day such demonstration is not needed, but eighty years since the idea was heresy to most people. Stubbs began his *Comparative Anatomical Exposition of the Structure of the Human Body, with that of a Tiger and common Fowl, in Thirty Tables*, during the year 1795. 'The first number contained an explanation of the skeleton; the second and third, a view of the external parts of the human body, and an enumeration of the organs lying under them, with a description of the common integuments taken off with the membrana adiposa and fat.' No more were published, owing to the author's death, but we are informed that in his fourth, fifth

Opposite: Fowl: Lateral view with Most Feathers Removed, preparatory drawing for the Comparative Anatomy *(graphite on paper) (after 1795)*

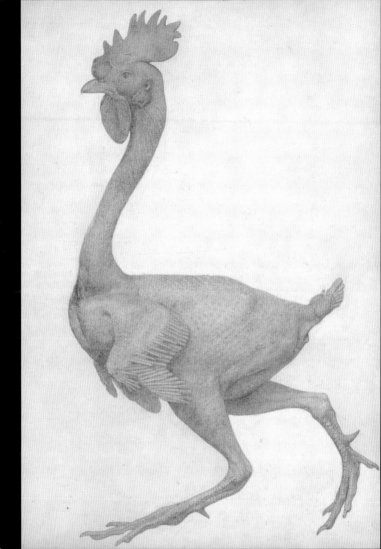

and sixth numbers, which should have completed the work, 'Mr. Stubbs meant to describe the first, second, and third lays of muscles taken off.' They are said to have been finished.

This was his last undertaking. He died in London, July 10, 1806, and was buried in Marylebone Church. Stubbs had no near relatives living, except Miss Spencer, to whom he left all his property. George Townley Stubbs, an engraver of merit, is reported to have been his natural son.

Several portraits of him remain. That in crayons, possessed now by Joseph Mayer, F. S. A., by Ozias Humphry, R. A., represents a stout man, with resolute features and severe expression.[1] His muscular strength was prodigious. We are told that he more than once carried a dead horse on his back up two or three flights of a narrow staircase to the dissecting room. He rose very early, ate little, and drank only water for the last forty years of his life. In 1803, under date of August 31, Mr. Upcott mentions that he took Samuel Daniell, nephew of the Academician, to call on Stubbs. 'We found him

1. Walker Art Gallery, Liverpool. See cover

engaged in engraving his series of anatomical plates, of which he had just completed the first number. This day he will have attained his seventy-ninth year,* and still enjoys so much strength and health that he says within the last month, having missed the stage, he has walked two or three times from his own house in Somerset Street to the Earl of Clarendon's at The Grove, between Watford and Tring, a distance of sixteen miles, carrying a small portmanteau in is hand.' Mr. Ozias Humphrey bears witness to the same feat, performed before 10 A.M. Only the day before his death he walked eight or nine miles, returning in very good spirits. At 3 A.M. on the following day, he awoke 'as well as ever he was,' but, on sitting up, a dreadful pain seized his chest. He dressed himself, however, and went downstairs, moving with accustomed ease. At nine o'clock, sitting alone 'in his arm-chair, wrapped in his gown,' he died silently.

* In the notes taken down from Stubbs' own mouth, his birthday is put at August 24

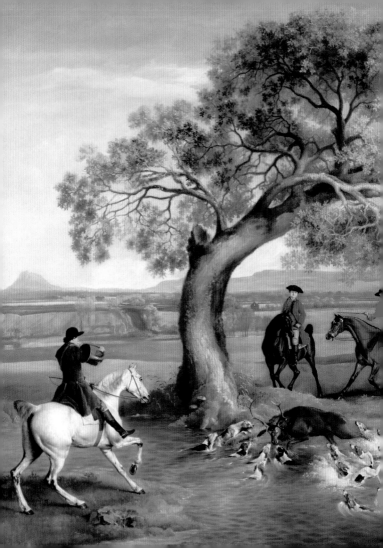

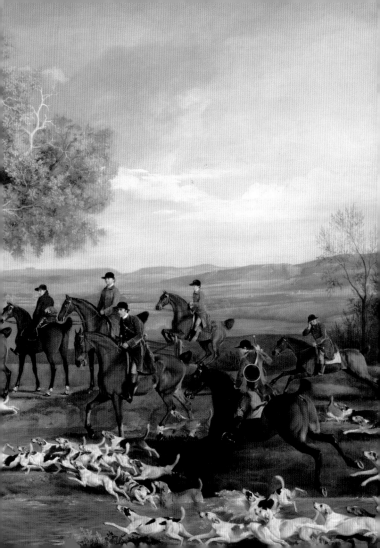

A LIST OF GEORGE STUBBS'
PICTURES,
WITH ANECDOTES

The first commission Stubbs received after taking up his residence in London was from Sir Joshua Reynolds, as has been said. It represented a War Horse, and remained in the artist's possession till his death, Sir Joshua having exchanged it for another picture. Stubbs at the same time executed important work for the Duke of Richmond at Goodwood. From thence, in 1760, he went to Eaton Hall, the Cheshire seat of Lord Grosvenor, to fulfil an engagement of long standing. In a visit of many months, he painted a favourite horse, Bandy;[1] and a large hunting piece.[2] In it were introduced portraits of Lord Grosvenor on Honest John, his brother, Mr. Grosvenor, Sir Roger Moston (?Mostyn), Mr. Bell Lloyd, and servants. A view from the drawing-room window of Eaton Hall forms the background of this picture, which is at Eaton Hall, near Chester, and we hope it will be placed by the Duke of Westminster, along with several others in possession of his Grace, in the new

1. Private collection 2. Private collection

Previous page: The Grosvenor Hunt, 1760-6.
Lord Grosvenor is the first figure to the right of the tree

picture gallery building as part of the alterations now making at that mansion. Two of the pictures, *Mambrino*[1] and the *Mares and Foals*,[2] are now (October 1876) exhibiting at 'The Art Treasures Exhibition of North Wales and the Border Counties,' at Wrexham.

The racehorse *Mambrino*,[3] which he engraved, was painted in 1768, together with a large picture of a group of *Mares and Foals* sheltering from the sun under some large oak trees, with fine landscape as a background.[4] Other works Stubbs executed in Cheshire, and proceeded thence to Newmarket, where he painted 'Snap' for Jeneson Shafto, Esq.[5] On return to town he made his first drawing of a lion from nature, finding his model at Lord Shelburne's villa, on Hounslow Heath. The animal's cage stood in a corner of the garden, and a gravel walk passed before it. The anger of the lion was thus roused continually at sight of people walking by, and Stubbs, who executed many drawings from him, profited by these fits of passion. The famous pictures of a lion devouring a stag,[6] and again, of a lion

1. Private collection 2. Private collection 3. Private collection.
4. Private collection 5. Untraced 6. Yale Center for British Art

Overleaf: Lord Torrington's Bricklayers at Southill, Bedfordshire, 1767. There was originally a Palladian lodge on the right, later overpainted

devouring a horse,[1] were drawn on this model for the Marquis of Rockingham. Besides oil pictures, we learn that Stubbs made many studies in pencil and black and white chalk, employing himself thus whilst waiting for favourable attitudes. The lion at Lord Shelburne's sat for most of his paintings, but he constantly visited the Tower for observation and comparison among the animals kept there.

At Southill, seat of Viscount Torrington, Stubbs did a great deal of work. It appears to have been in 1778 that he painted his favourite picture of *The Bricklayers*.[2] The idea of it was Lord Torrington's. He had often watched his men at work, and thought what a telling picture might be made of them in the Flemish style. The horse represented was a favourite old hunter, the first his lordship ever rode. Stubbs tells us that he was a long time in catching the idea, making the men load and unload their cart, which they did in a style that scarcely lent itself to painting. At length they fell into a quarrel about the manner of fixing the tail-piece in a cart, and gave the watching artist his opportunity. This picture was the 'sensation' of the exhibition, when it appeared, many seasons afterwards. Of *The Bricklayers* there were several repe-

1. . Yale Center for British Art 2. Philadelphia Museum of Art

titions, particularly one in enamel of an oval form, 3 feet wide by 2 feet 4 inches high. This was bought by Mr. Wedgwood, and long remained one of the ornaments of Etruria Hall.[1] After Mr. Wedgwood's death it was disposed of. Thomson West, Esq., bought another repetition, in which that gentleman himself is introduced, sitting on a favourite horse, and enjoying the dispute. Stubbs painted in enamel another copy of the same subject for Erasmus Darwin, the author of the *Botanic Gardens* and the *Loves of the Plants*. This was the largest plate of earthenware Mr. Wedgwood ever made, and is in possession of the present Dr. Darwin.[2] The original picture Stubbs engraved himself.

A hunting scene was also painted for Lord Torrington, with portraits of his coachman, grooms, hunstman, and whipper-in, surrounded by their dogs. The village of Southill forms a background to this picture.[3]

Another composition represented his lordship's steward, on an old horse, with the gamekeeper and a Pomeranian dog.[4] It was painted in enamel on

1. Yale Center for British Art 2. Untraced 3. Private collection
4. Private collection

Overleaf: Lord Torrington's Hunt Servants setting out from Southill

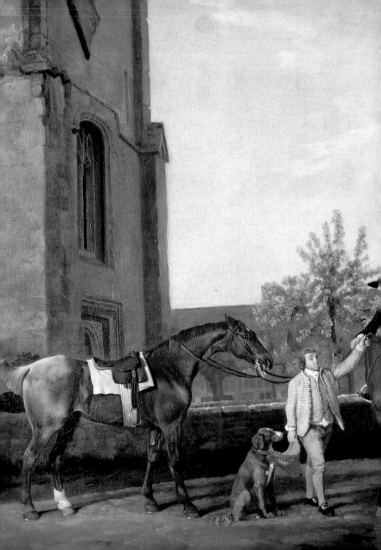

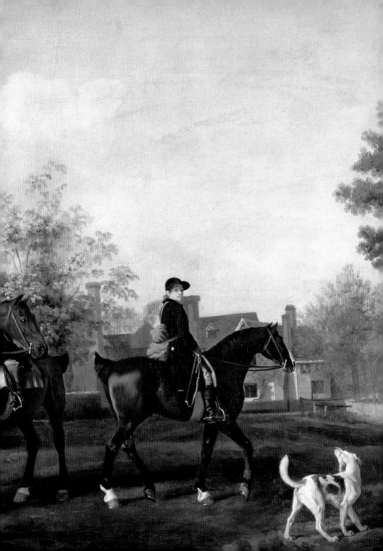

copper, as was the portrait of a pointer dog, which Lord Torrington declined to take. This picture, on an octagon plate, within a circle of 12 inches diameter, was afterwards sold to Captain Urmstone of the Francis East Indiaman, and taken to India.[1]

For the Marquis of Rockingham, at Wentworth House, Stubbs painted a life-size portrait of *Whistlejacket*,[2] a yellow-sorrel horse, with white mane and tail. The Marquis had intended to employ some eminent painter of portraits to add a likeness of King George the Third sitting on Whistlejacket's back, and some landscape painter of equal excellence to execute the background. He designed, in fact, to have a pendant to the picture by Moriere and others hanging in the great hall at Wentworth House. The idea, however, was abandoned under circumstances very flattering to the artist. Whistlejacket had a temper so savage that only one man could be trusted to take him to and from his stable. The last sitting proved to be shorter than Stubbs had expected, and his work was finished before the time fixed for this man to come as usual, and lead the horse away. Whilst the boy in charge of him waited, Stubbs put his work in a good light and observed its effect, as

1. Private collection 2. National Gallery. See frontispiece

artists do. The boy, who was leading Whistlejacket up and down, called out suddenly, and turning, Stubbs saw the horse staring at his own portrait and quivering with rage. He sprang forward to attack it, rearing, and lifting the boy off his legs. Very hard work they had to preserve the picture. When the Marquis heard this story, it pleased him so much that he would not allow a single touch to be added, but framed and hung the picture without a background. For the King's likeness another horse was chosen, a dark bay with black tail, named Scrubb.[1] This picture was immediately executed, but upon some dispute with the Marquis, Stubbs took it away. It was afterwards sold to Mr. Ryland, who sent it, with others, to India. They never landed, and on the vessel's return, the painting was found to be so much damaged that the artist took it back again in part payment of his account with Ryland. After re-painting, it was sold to Miss Saltonstall, and, many years after, she had it at her house, Hatchford, near Cobham, Surrey.

Many other pictures did Stubbs paint at Wentworth House. Notable among them were three views of Samson, a very large black stallion, on one canvas, representing him in front, back and side view.[2]

1. Private collection 2. Private collection

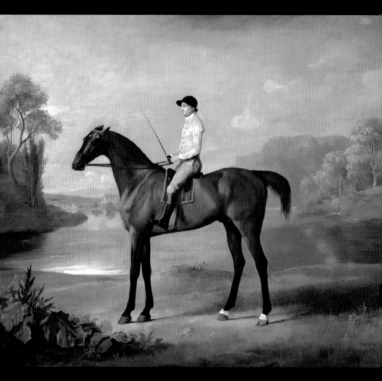

The Marquess of Rockingham's Scrubb with John Singleton up, 1762

He painted also a small Bengal cow, with a favourite lap-dog of the Marchioness.[1] All these pictures were the size of life. Amongst smaller portraits we find another view of Scrubb, with his lordship's jockey on his back. The man observed, with some humour, that 'on many a *good* horse, and many a *bad* one, had the Marquis mounted him, but now he was set upon a Scrubb for ever.' This was a half-length canvas.[2]

In London, Stubbs painted several pictures for the Marquis of Rockingham. The first of these represented a *Lion Devouring a Stag*,[3] and another, a *Lion Devouring a Horse*.[4] Both of them were engraved.

Of equal merit is *The Horse Affrighted by a Lion*.[5] The animal, a white one, was painted from one of the King's horses, which Mr. Paine, the architect, obtained Stubbs' leave to copy. The expression of terror was produced by pushing a brush towards him along the ground.

Stubbs painted his *Fall of Phaeton*,[6] with roan horses, on speculation, and Sir Joshua Reynolds was so pleased with it that he begged to exchange the

1. Untraced 2. Private collection 3. & 4. Yale Center for British Art 5. Walker Art Gallery, Liverpool 6. Saltram House, Devon

picture he had ordered for this one. The horses of Phaeton were drawn from a set of coach-horses belonging to Lord Grosvenor. Stubbs made a repetition of the subject, with great improvements, for Colonel Thornton.[1] By many judges this is thought to be his masterpiece. The horses in Colonel Thornton's picture are white, drawn from one of his own coach-horses. M. Sergel, the sculptor of the King of Sweden, saw it in returning from Rome, and he declared the drawing of the animals, their life and expression, to be equal to the finest antique sculptures. The same subject was repeated in enamel, on a copper plate, eighteen inches by fifteen.[2]

Those enumerated are the most important works of George Stubbs, with the *Grey Mare*,[3] which was his first success; the *Godolphin Arabian*,[4] *Brood Mares*,[5] *Fight of Lions and Tigers over a Stag*,[6] and the *Horse Frightened by a Lion in a Cave*.[7] The two latter are in the possession of Mr. Joseph Mayer. Stubbs executed commissions for Sir Henry Vane Tempest,[8] Lord Gormanston, the Duke of Newcastle, and many other eminent patrons. For the Duke of Marlborough he painted a Bengal

1. Untraced 2. Private collection 3. Untraced 4. Untraced 5. Several pictures are possible 6. Untraced 7. Williamson Art Gallery, Birkenhead; possibly not by Stubbs 8. Including *Hambletonian: Rubbing Down* (see page 88)

tiger with such skill that dogs are said to have been frightened on seeing it.[1]

The most notable of his pictures in enamel are, besides those already mentioned:

Horses Fighting,[2] painted from Nature without those preparations usual for work of this class.

His own portrait, sitting on a white horse.[3]

Portrait of Miss Saltonstall, in the character of Una.[4]

Portrait of a Youth, William Shafto, Esq.[5]

A small rough lap-dog, the size of life, painted for Mrs. French.[6]

Another portrait of himself, life-size, painted for Mrs. Therold.[7]

Portrait of Dr. Hardy, M.D., for the same lady. This is half the size of life.[8]

Farmer's Wife and Raven, from Gay's *Fables*, sold to Mrs. Armstead for one hundred guineas. This is an oval plate, three feet wide.[9]

None of these pictures exist in oil colour.

1. Private collection 2. Yale Center for British Art 3. Lady Lever Art Gallery, Port Sunlight (see page 6) 4. Fitzwilliam Museum (see page 22) 5. Possibly the *Portrait of a Man called Huth*, private collection 6. Untraced 7. National Portrait Gallery 8. Untraced 9. Yale Center for British Art

Overleaf: Hambletonian: Rubbing down (1800)

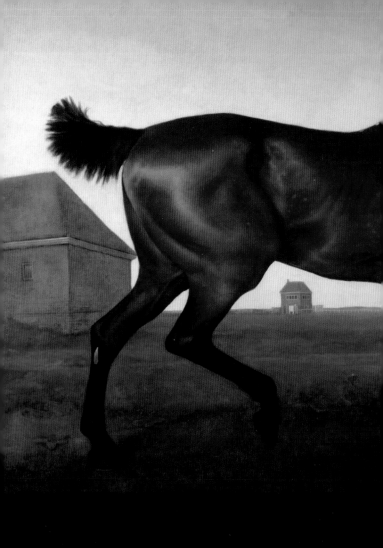

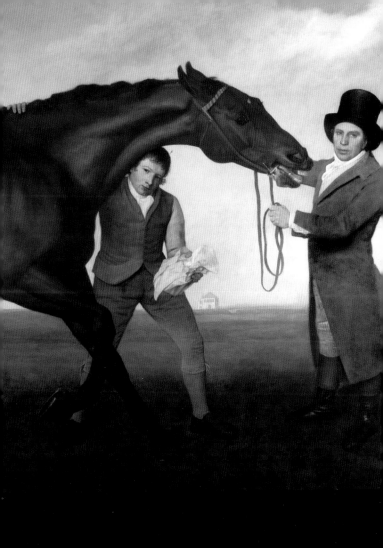

We know that Stubbs engraved eighteen of his own paintings, amongst them the following:

The Bricklayers, and a companion.
The Farmer's Wife and Raven.
Haymakers and *Reapers.*
A Horse Frightened by a Lion, and its
 companion, *Tigers at Play.*
A Lion Devouring a Horse.
Two Tigers.
A Lion.
A Tiger.
Three prints of single dogs.
A Lion Devouring a Stag.

It had been his intention to engrave all his pictures on enamel in the same size as the painting; but, on observing what large glasses would be needful, he abandoned the idea. Glass at that time was very expensive, and Stubbs feared that his prints would not sell. There exists, also, a lithograph of a Lion by his hand, published as a prospectus.

In 1823 Thomas Landseer, father to Sir Edwin, produced *Twenty Engravings of Lions and Tigers*, &c., &c., with an admirable figure of a lion on the title-page. It is to be observed that Stubbs' name heads the list of painters in that work, placed above Rubens,

Snyders, and all the famous masters. Not only so, but it is printed in type twice as large. Of the opinion of Sir Edwin Landseer I have already shown something.

The Royal Collection at Schleissheim, near Munich, contains a picture of a *Sporting Dog*[1] by George Stubbs — described in the catalogue of that superb gallery as

A faithful and spirited portrait of a Pointer, painted by an English artist, who at the latter end of the last century, was famous for his pictures of sporting subjects, and for his portraits of the most celebrated racers of his time, which he not only designed with correctness, but with a characteristic spirit, for which he was particularly distinguished. Though chiefly engaged in this branch of art, his talents were capable of higher exertions. As in the picture before us, his backgrounds often show considerable talent as a landscape painter; and his picture of *Phaeton and the Horses of the Sun* was greatly admired.

The design of this paper does not leave room for a detailed criticism of Stubbs' ability. We wished only to rescue some memorials of a painter who

1. Neue Pinakothek and Staatsgalerie, Munich

occupied high place in his time, but who is now overlooked. The judgment of his best contemporaries has been practically shown, but something should be said perhaps of the impression which his works produce upon eyes trained to the modern point of view. To admit that Stubbs' paintings mostly disappoint the crowd is no disparagement of the artist. Quite the contrary; for he who knows what manner of beast was given Englishmen to admire before Stubbs' day, best recognises what we owe him. His obstinacy in rejecting the models of other men, saved him from falling into the exaggerations of any school. Because his horses and his animals are correctly drawn, because they have that kind of expression, and no other, belonging to their kind, the unthinking pass them with a glance, and call them commonplace. Nobody stands to stare at a picture by George Stubbs as before one of the earlier and more famous painters, in which reckless disregard of truth compels a wandering attention. His dogs and horses are the real, living thing, to which everybody is accustomed, and it will be long before the outer world quite understands that truth is the highest art. Stubbs was first to paint animals as they are. No temptation led him to invent a muscle, nor did he put his creatures into an attitude. They are

always as Nature made, with their own shapes, gestures and expressions — often ugly, but always true. This old-world painter would have refused to illustrate a human feeling, a drama of human interest, in pictures of animal nature. He painted what he saw, and never showed an immortal soul in a poodle's eye.

Declining thus to dramatise his beasts, or even to idealise them overmuch, of necessity he circumscribed his sphere of art, according to modern notions. Of each expression properly belonging to an animal — and coming in the range of his experience — he was master; but he created none, nor conceived what he had not beheld. Barye himself never painted scene more terrific than Stubbs' *Horse Frightened by a Lion*, for the artist knew each vein that swells, each muscle that relaxes or distends, when a horse is struck motionless by terror. And he knew the attitude and cruel eye of a lion crouching for the spring. But he did not know how lion meets tiger across a prey, having no advantage over Snyders in such work, saving correctness of anatomy. For which reason his pictures of the kind are less satisfactory, wanting as he did the great Dutchman's imagination. We see this lack of fancy in the details and the backgrounds. Barye's landscapes give one a chill, a

sense of horror, before one marks the shadowy wild beast which claims possession of that awful solitude. Stubbs had no such dramatic power. His animals have no appropriate scenery of their own. But his command of the brush was remarkable, both in landscape and in painting 'texture.' A *Landscape with Horse* by his hand was sold at Christie's last June, in which water, sky, and scenery were rendered with no less excellence than was the fine hunter in the foreground. Amongst a number of admirable modern pictures it fetched £100. 16s., a proof that George Stubbs' work still holds its own though his memory has faded.

POSTSCRIPT.—How utterly it has faded we are given fresh evidence to-day, November 1, 1876. For in the *Hand-book to the department of Prints and Drawings in the British Museum, with introduction and notices of the various schools, Italian, German, Dutch and Flemish, Spanish, French, and English,* by Louis Fagan, just published, there is no mention of Stubbs as an artist, as a painter, or an engraver. Surely the old man was right to decline striving too earnestly for academical honours, which, when granted, could not preserve his very name for a hundred years.

Illustrations

Cover: Portrait of George Stubbs by Ozias Humphry © Walker Art Gallery,
Liverpool

p. 1 & p. 72 The Grosvenor Hunt, Private Collection

p. 2 Whistlejacket, © National Gallery, London

p. 4 A Lion attacking a Horse © Yale Center for British Art,
Paul Mellon Collection

p. 6 Self-portrait © Lady Lever Art Gallery, Port Sunlight, Merseyside, UK

p. 10 A Cheetah with two Indians and a Stag, Manchester City Art Gallery

p. 14 Sir John Nelthorpe, Private Collection

p. 17 Joseph Smyth, Lieutenant of Whittlebury Forest
© Fitzwilliam Museum, Cambridge

p. 20 The Melbourne and Milbanke families © National Gallery, London

p. 22 Isabella Saltonstall in the character of Una ©Fitzwilliam Museum, Cambridge

p. 24 Lord Grosvenor's Arabian Stallion with a groom
© Kimbell Art Museum, Fort Worth

p. 28 The Prince of Wales's Phaeton, with the Coachman
Samuel Thomas and a Tiger-Boy © Royal Collection

p. 35 Green Monkey, Private Collection

p. 38 Portrait of George Fothergill of York © Ferens Art Gallery,
Hull City Museums and Art Galleries

p. 44 & p. 46 Plates from *The Anatomy of the Horse,* © Pallas Athene

p. 50 Mares and Foals, Private Collection

p. 55 Gimcrack with John Pratt up © Fitzwilliam Museum, Cambridge

p. 56 The Fall of Phaeton © National Trust, Saltram House

p. 58 The Duke of Richmond's racehorses at exercise
© The Trustees of the Goodwood Collection, Goodwood House, Chichester

p. 62 Reapers © Yale Center for British Art, Paul Mellon Collection

p. 66 Mambrino, Private Collection

p. 69 Fowl: Lateral view with Most Feathers Removed
© Yale Center for British Art, Paul Mellon Collection

p. 76 The Bricklayers, Philadelphia Museum of Art

p. 80 Lord Torrington's Hunt Servants setting out, Private Collection

p. 84 Scrubb with John Singleton up, Private Collection

p. 88 Hambletonian, Rubbing Down © National Trust, Mount Stewart

Illustrations on pp. 1, 2, 4, 6, 14, 20, 35, 38, 50, 62, 66, 69, 84 and the cover
courtesy of Bridgeman Picture Library. Others as noted

First published 2005 by
Pallas Athene,
42 Spencer Rise,
London NW5 1AP
www.pallasathene.co.uk
© Pallas Athene 2005

ISBN 1 84368 002 5

Special thanks to Anthony Mould,
Barbara Fyjis-Walker,
and Stephen Lennon

Textual Note:

This text of the *Memoir* by Ozias Humphry
is taken from the edition prepared by Joseph Mayer
and privately printed by him
in 1876 (as part of *Early Art in Liverpool*)
and again in 1879
(as part of *Memoirs of Thomas Dodd, William Upcott
and George Stubbs RA*).
The Humphry manuscript from which Mayer worked,
together with the transcript by Humphry's
relative William Upcott,
remains in the Picton Library, Liverpool,
to which it was bequeathed by Mayer